Fun to Draw Funny Characters

T. Beaudenon

IMPACT
CINCINNATI, OHIO
www.impact-books.com

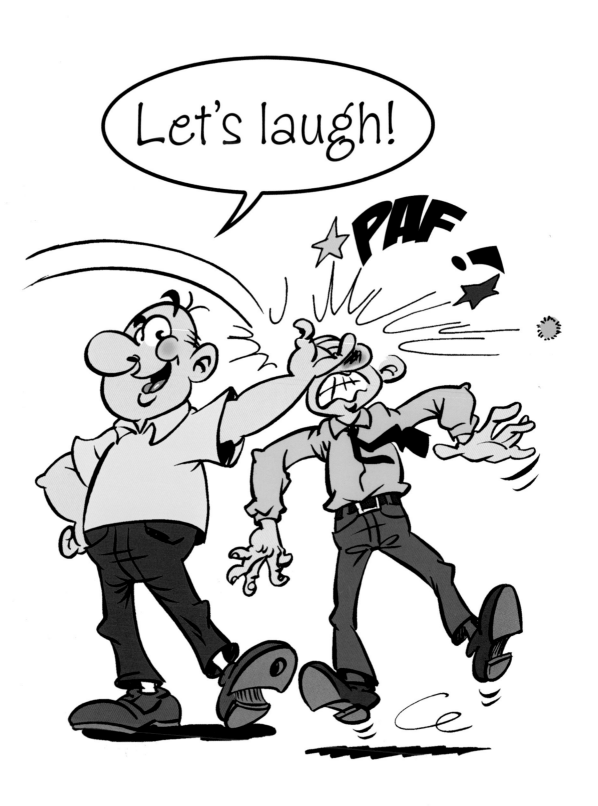

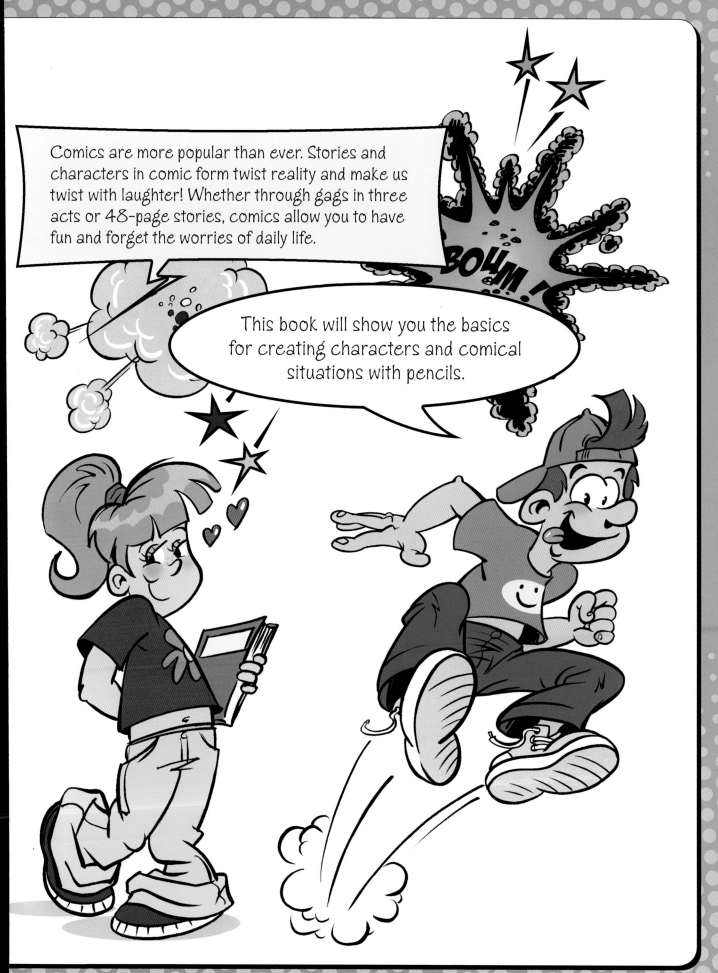

Comics are more popular than ever. Stories and characters in comic form twist reality and make us twist with laughter! Whether through gags in three acts or 48-page stories, comics allow you to have fun and forget the worries of daily life.

This book will show you the basics for creating characters and comical situations with pencils.

An Anatomy of Comic Proportions

In a comic strip, you will notice that the characters don't have the body proportions of normal humans. Taking the head as a reference, a man can be broken up into nearly eight or nine parts, while comic heroes have only four to six. In reality, there aren't any defined rules, it all depends on the role that you give to your character: You will use his body to characterize him. So, a tall, slender character will not play the same role as a short, fat one.

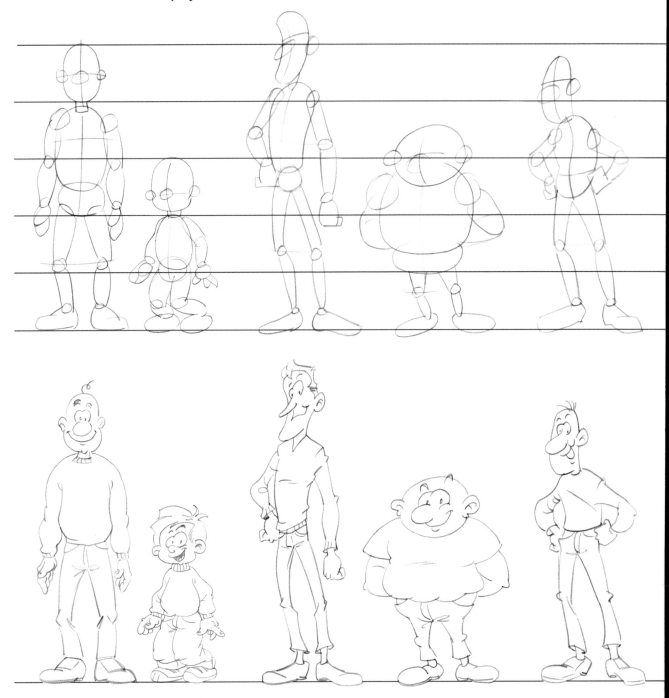

Different Character Proportions

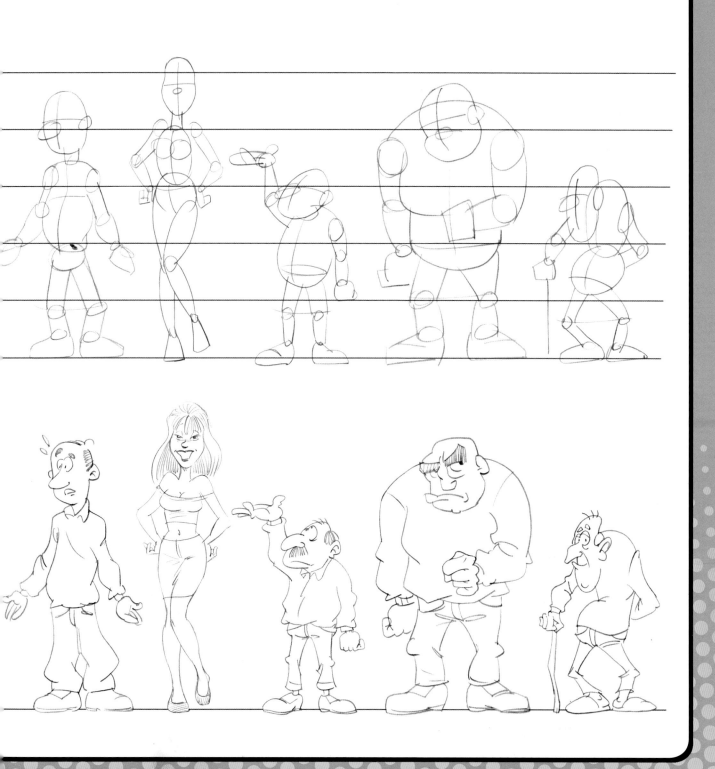

Basic Funny Faces

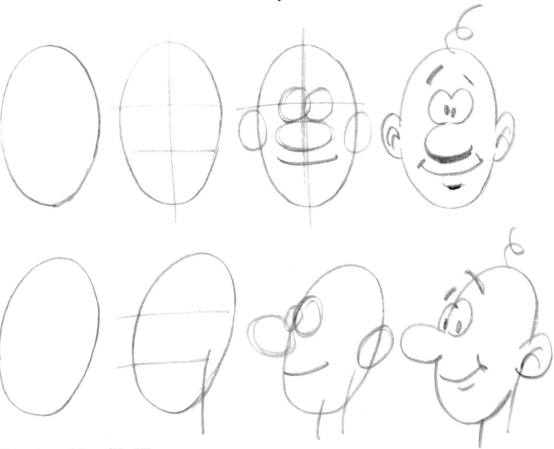

Front and Profile Views

To draw a face, draw a simple oval. Trace a median line, then draw two horizontal lines for placing the eyes and the mouth. You will notice that the ears are aligned along the line of the nose. The eyes, the nose and the ears are sketched using round forms. Before adding details, sketch the mouth with a simple curve, and you've got a funny character!

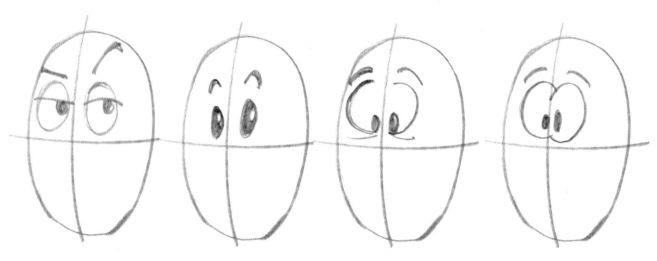

The Eyes

For eyes, simply draw two ovals with two black points to represent the pupils. Then, you can vary the shapes, separate the two eyes or stick them together.

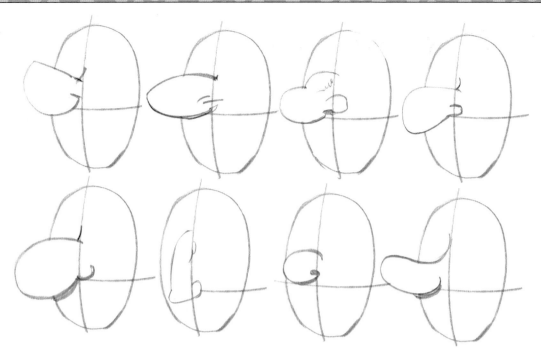

The Nose

There are a few different types of noses. Whether potato-like, trumpet-like, smashed or curved, the nose is the center of attraction of the face. With varying forms, it characterizes the character. A nose can express more than the eyes or the mouth. Change the form of the nose to change the expression of your heroes!

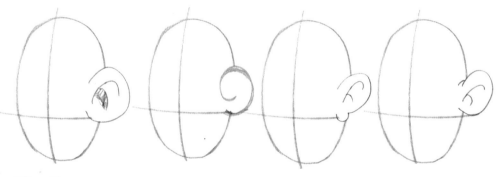

The Ears

Simplify ears to give them a more exaggerated and a slightly grotesque look.

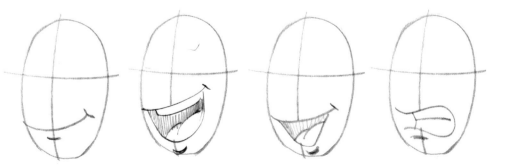

The Mouth

Just use a curve for the mouth. To make it smile or to show other emotions, open it in a half circle, a triangle, show the teeth, the tongue, etc.

Face Shape

Taking inspiration from simple geometric shapes, you can construct different and fun faces. You can also combine shapes to get a more complex result.

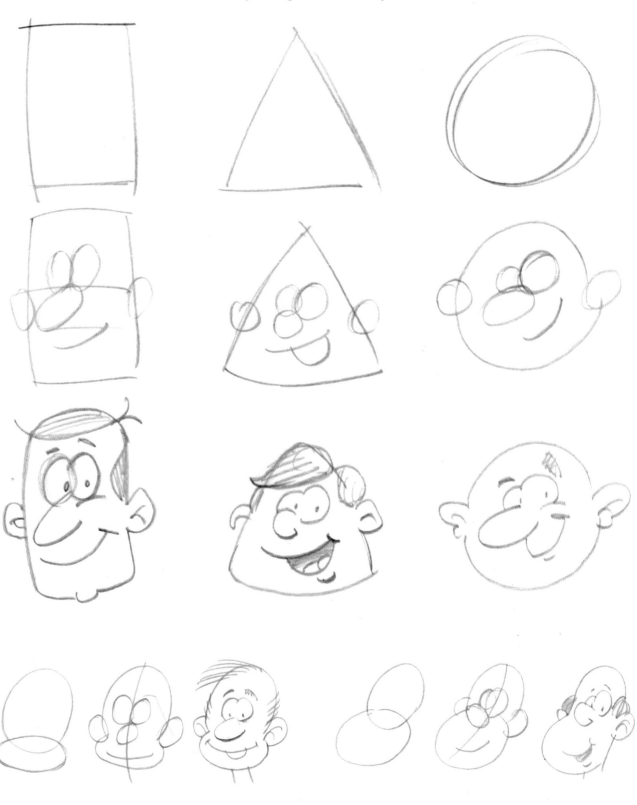

You can also use the shapes that you find in your kitchen! The result is always fun and wonderful! Take inspiration:

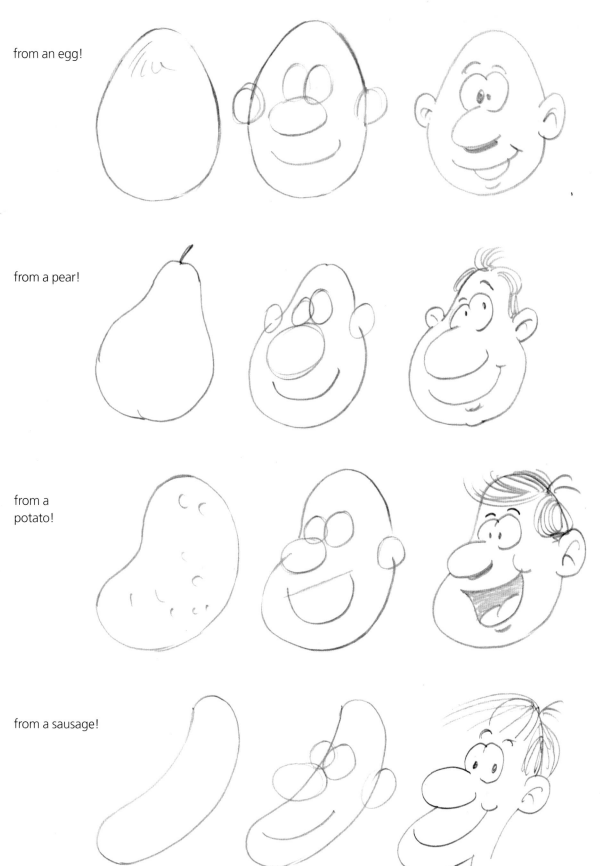

from an egg!

from a pear!

from a potato!

from a sausage!

Basic Expressions

Comic heroes always have exaggerated and outsized or unusual expressions. Here is a range of basic expressions.

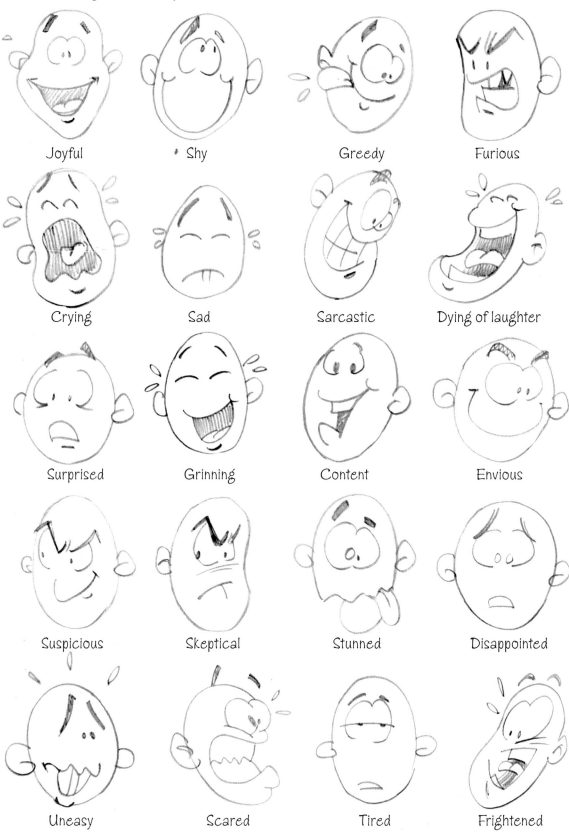

Joyful

Shy

Greedy

Furious

Crying

Sad

Sarcastic

Dying of laughter

Surprised

Grinning

Content

Envious

Suspicious

Skeptical

Stunned

Disappointed

Uneasy

Scared

Tired

Frightened

Hand Gestures

Hands play an important role in the lives of comic characters. They are often associated with an attitude. To sketch them, you must simplify.

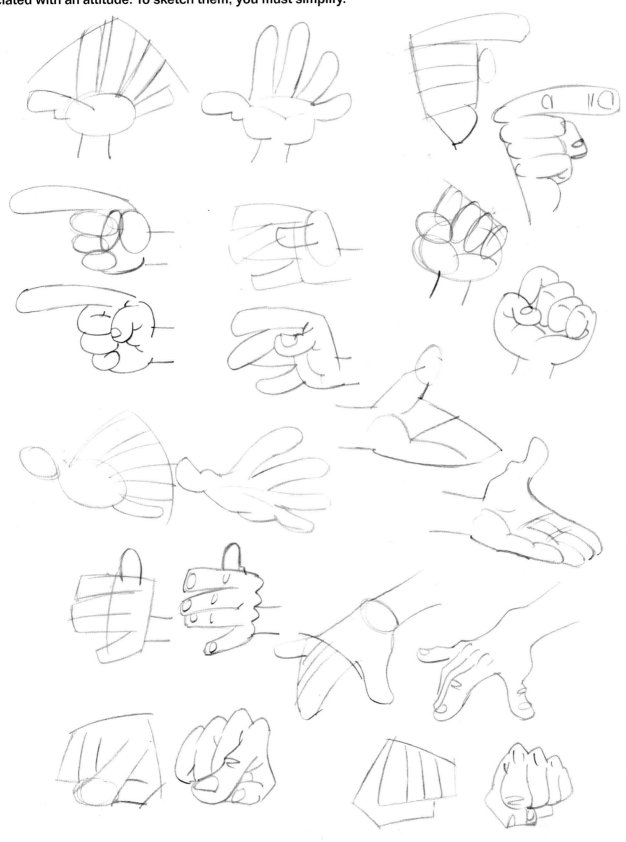

Laughter and Bumps

How do you draw an angry character that's funny?
How can a fall be funny? Here are some tips.

Hit on the Head

A hit on the head provokes a large bump and a headache!

And may have your character seeing stars.

Don't draw the action; suggest it by showing the impact on the head, the features of movement and the "bong!"

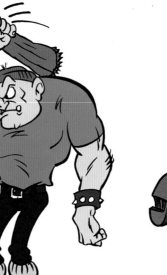

The Lump

Making a character all red will make him look even more ridiculous and on edge!

Shaking with laughter!

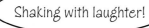

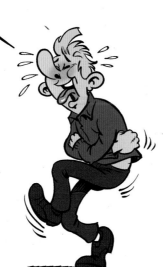

The arrows and the smoke accentuate the action.

Laughter

Temper

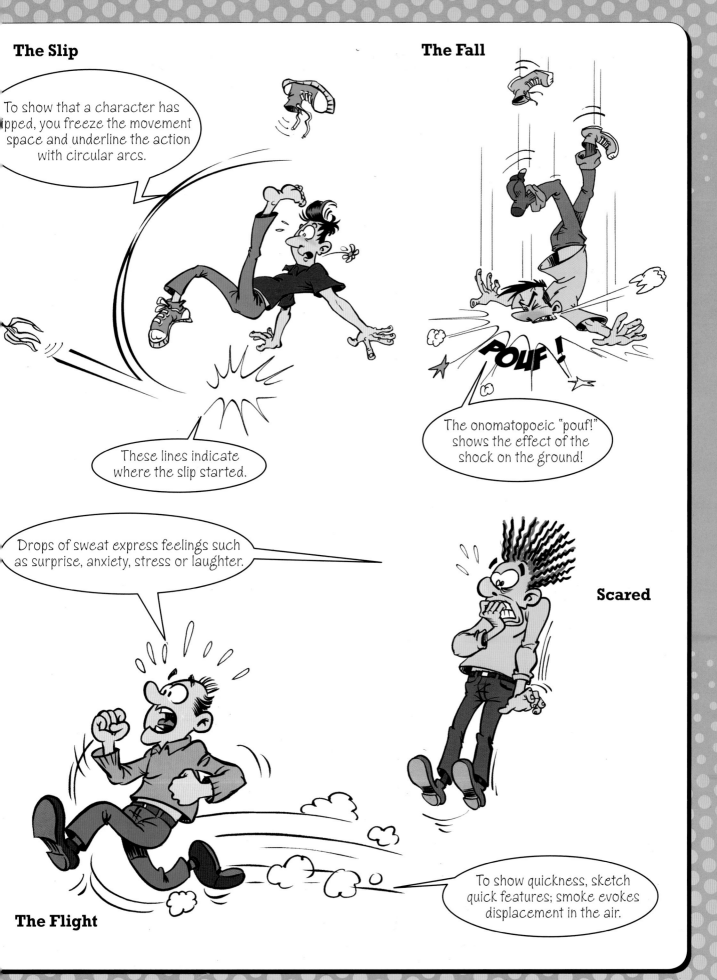

The Slip

To show that a character has slipped, you freeze the movement space and underline the action with circular arcs.

These lines indicate where the slip started.

The Fall

The onomatopoeic "pouf!" shows the effect of the shock on the ground!

POUF!

Drops of sweat express feelings such as surprise, anxiety, stress or laughter.

Scared

To show quickness, sketch quick features; smoke evokes displacement in the air.

The Flight

Friends for Life

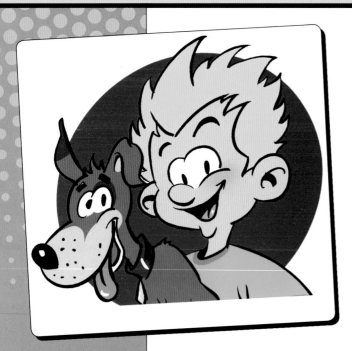

1 Line of Action

2 Sketch the Body

3 Add Volume

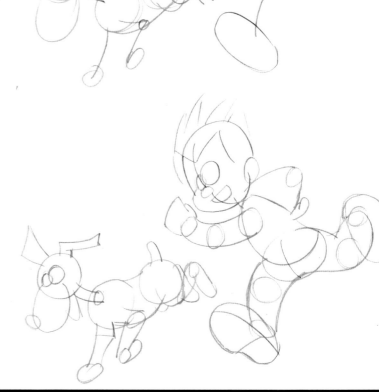

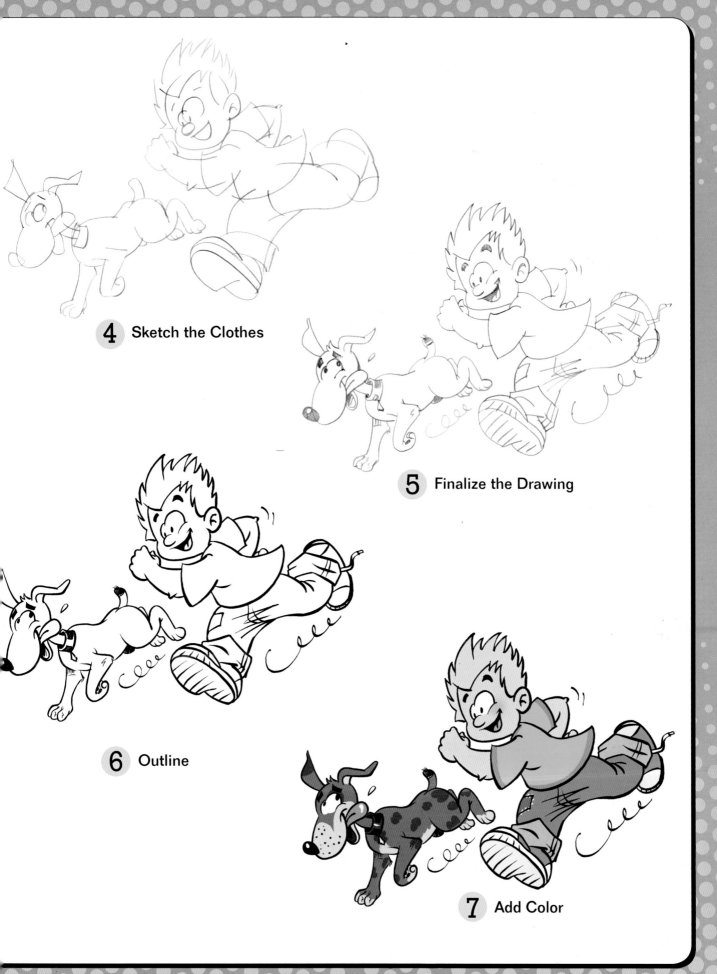

4 Sketch the Clothes

5 Finalize the Drawing

6 Outline

7 Add Color

The Shy Romantic

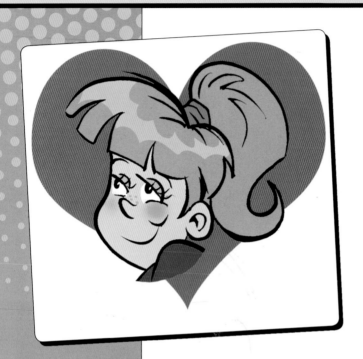

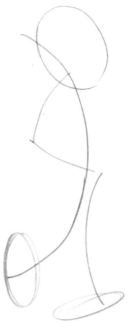

1 Line of Action

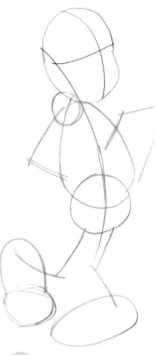

2 Sketch the Body

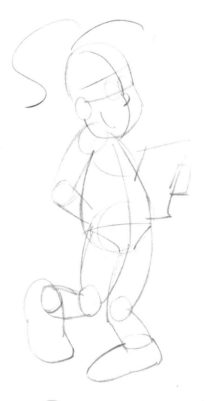

3 Add Volume

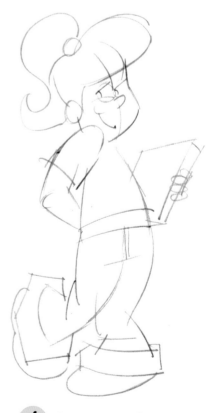

4 Sketch the Clothes

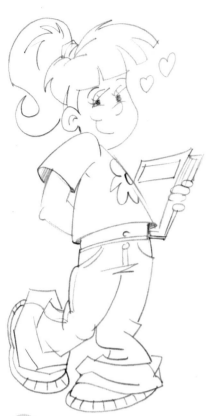

5 Finalize the Drawing

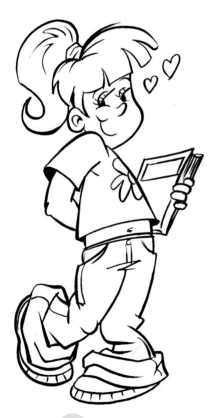

6 Outline

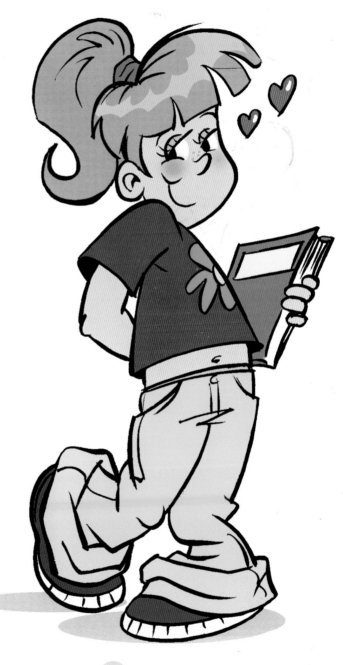

7 Add Color

The Brain

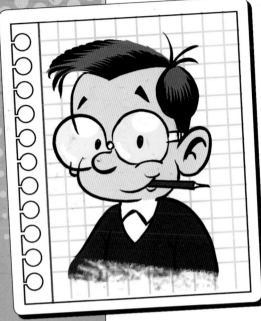

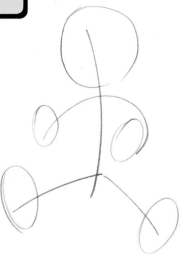

1 Line of Action

3 Add Volume

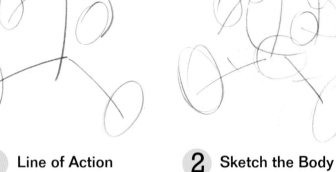

2 Sketch the Body

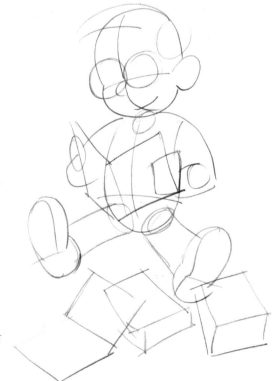

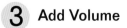

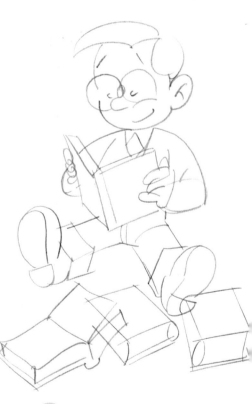

3 Add Volume

4 Sketch the Clothes

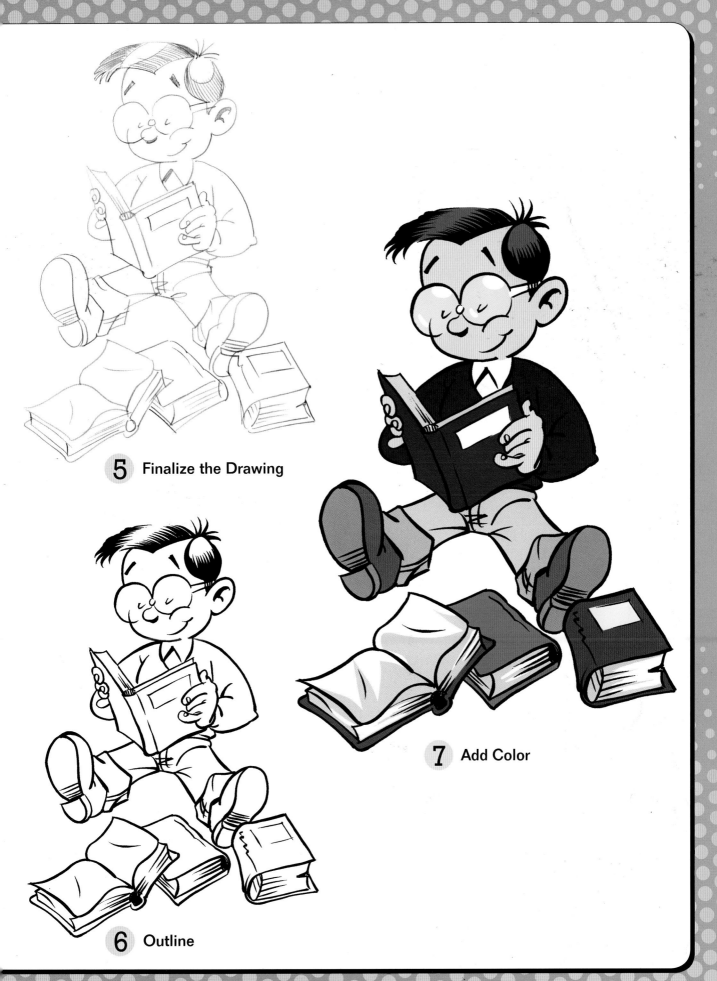

5 Finalize the Drawing

6 Outline

7 Add Color

Best Bud

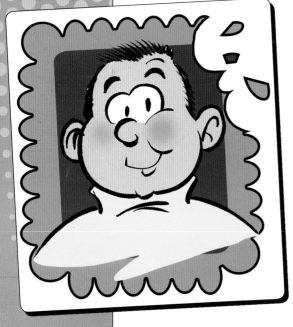

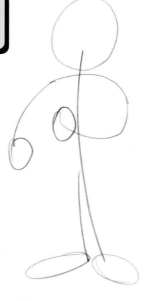

1 Line of Action

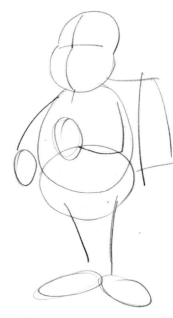

2 Sketch the Body

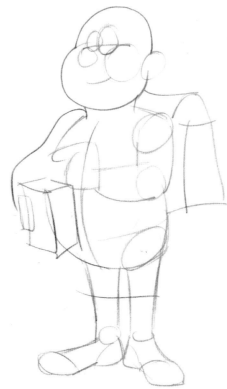

3 Add Volume

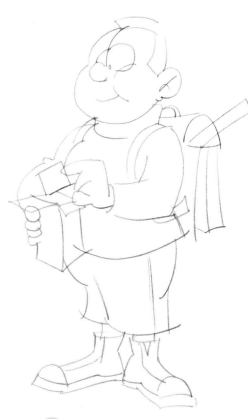

4 Sketch the Clothes

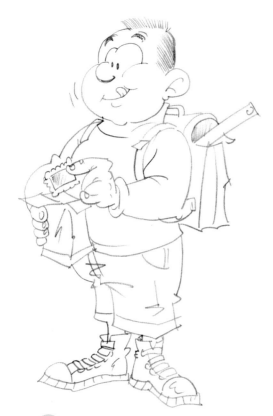

5 Finalize the Drawing

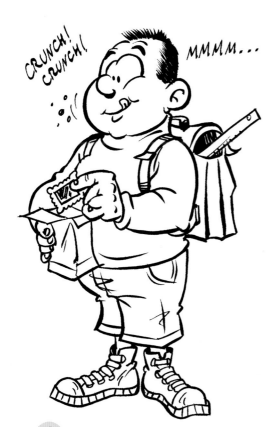

6 Outline

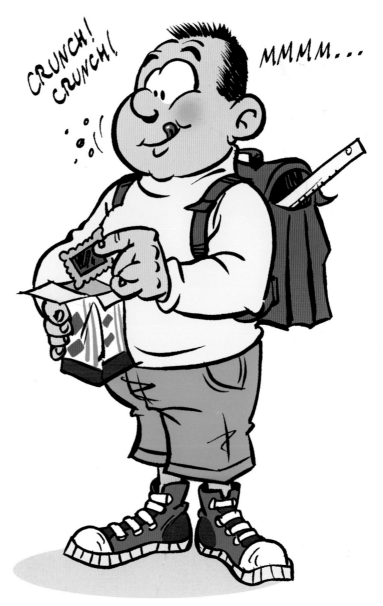

7 Add Color

The Mean Girl

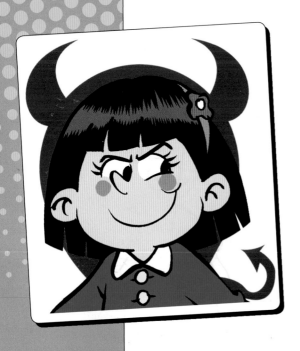

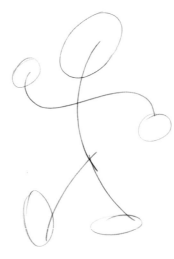

1 Line of Action

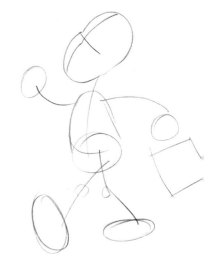

2 Sketch the Body

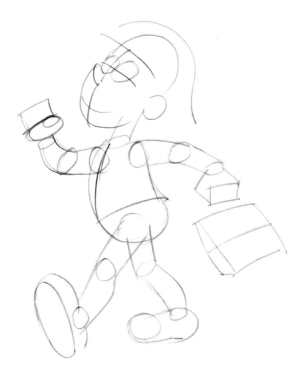

3 Add Volume

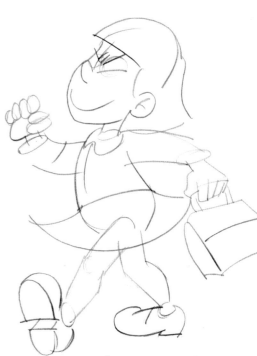

4 Sketch the Clothes

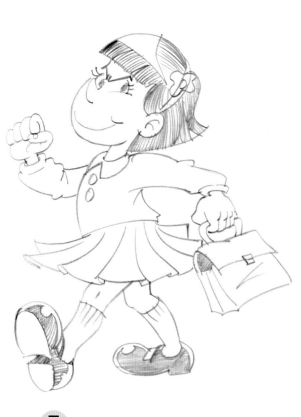

5 Finalize the Drawing

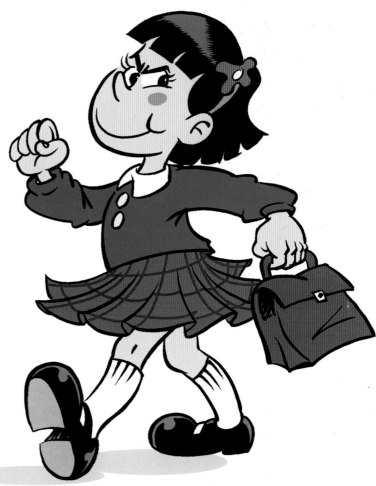

7 Add Color

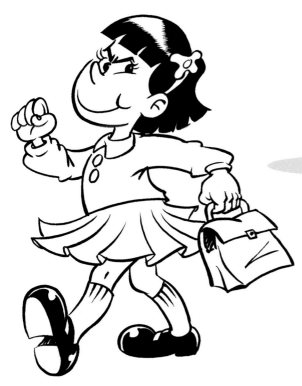

6 Outline

The Hyper Boy

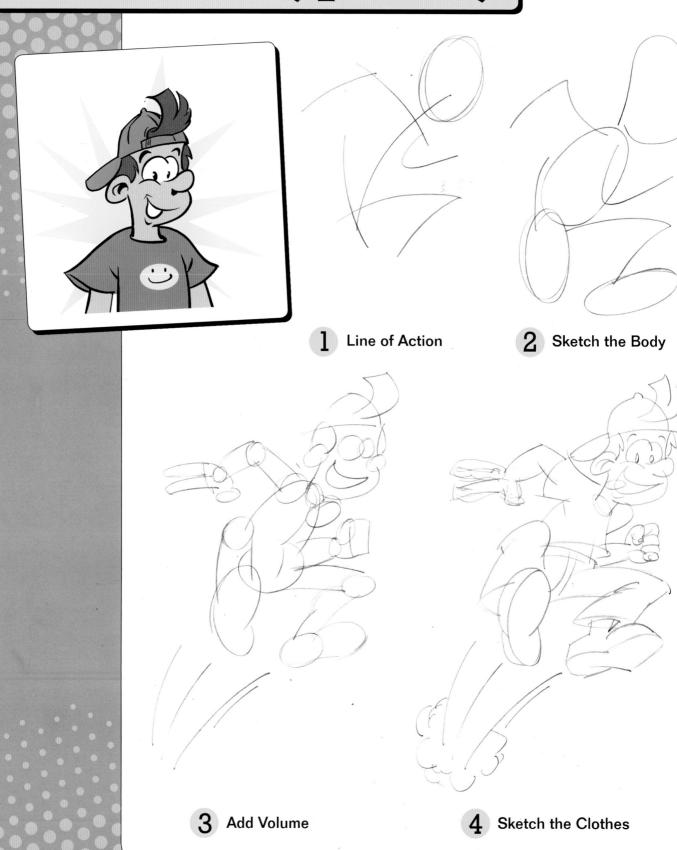

1 Line of Action

2 Sketch the Body

3 Add Volume

4 Sketch the Clothes

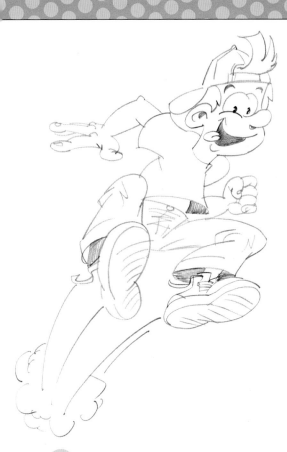

5 Finalize the Drawing

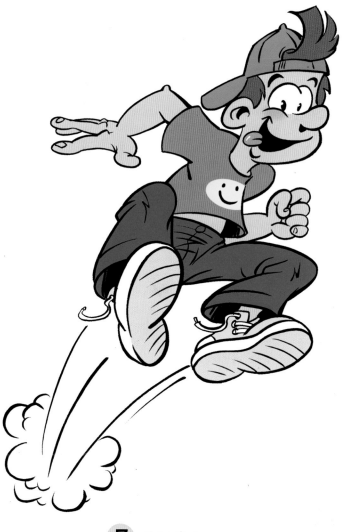

7 Add Color

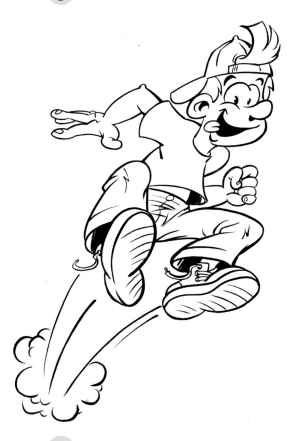

6 Outline

The Strict Teacher

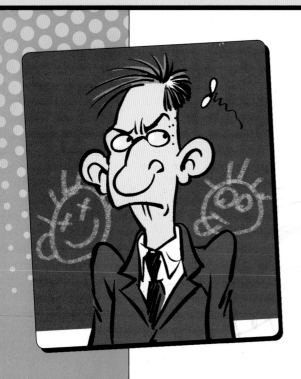

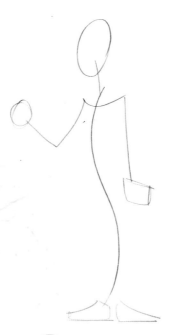

1 Line of Action

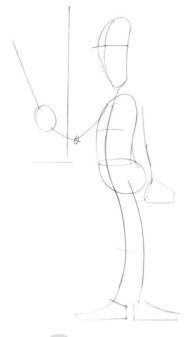

2 Sketch the Body

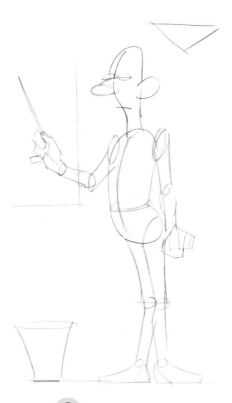

3 Add Volume

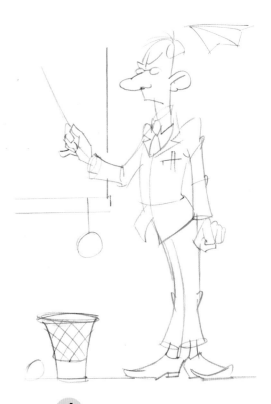

4 Sketch the Clothes

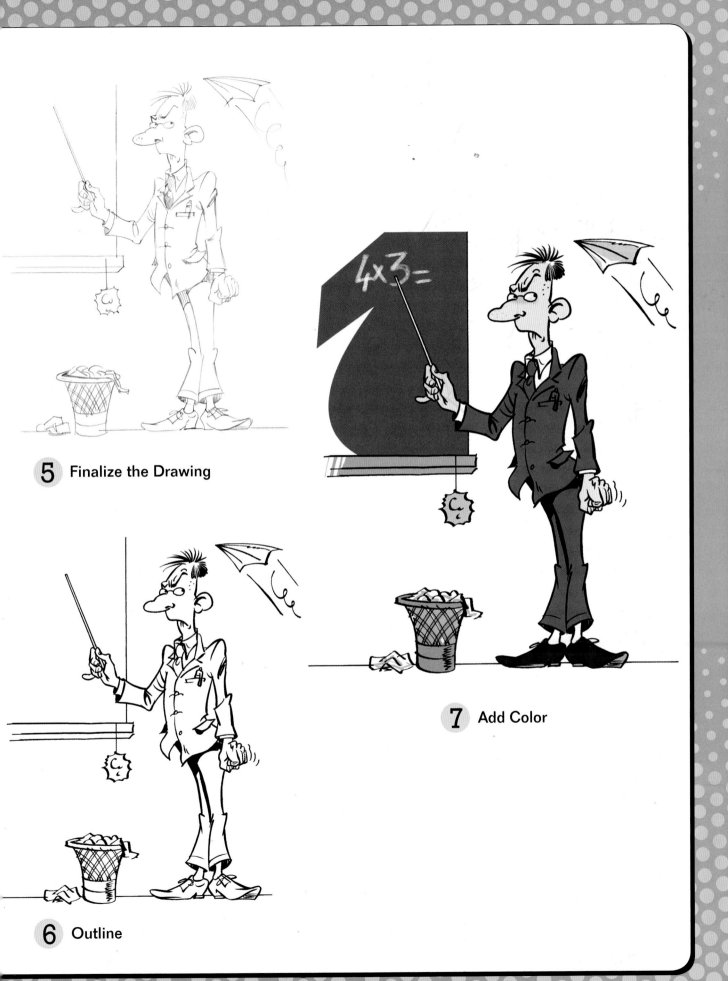

5 Finalize the Drawing

7 Add Color

6 Outline

The Dreamer

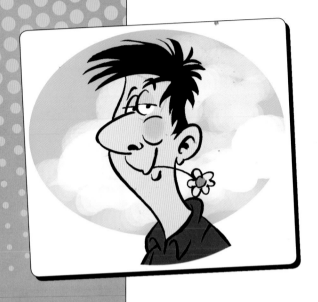

1 Line of Action

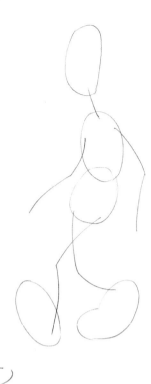

2 Sketch the Body

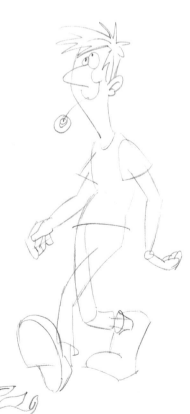

3 Add Volume

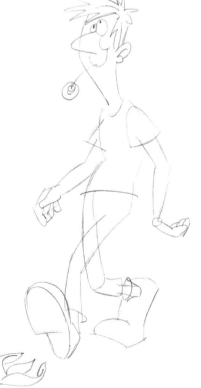

4 Sketch the Clothes

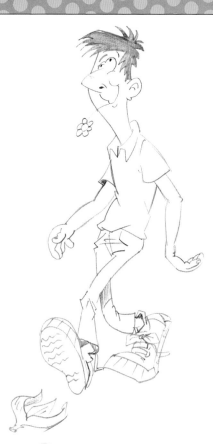

5 Finalize the Drawing

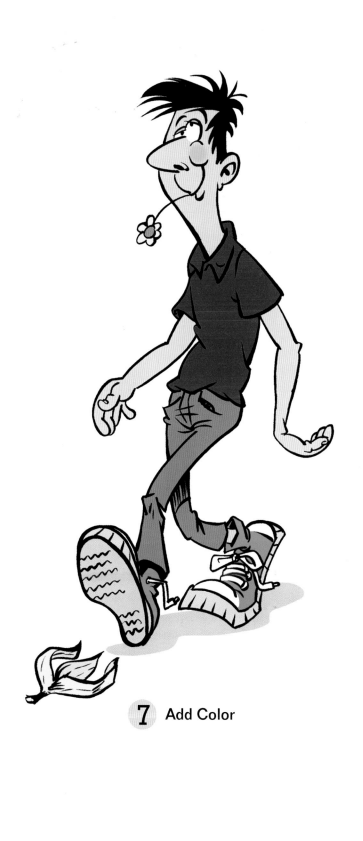

7 Add Color

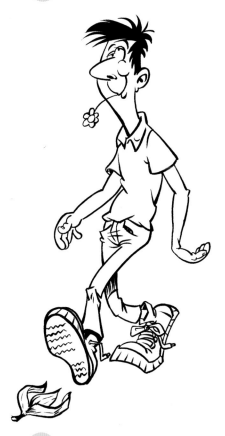

6 Outline

Graff Boy

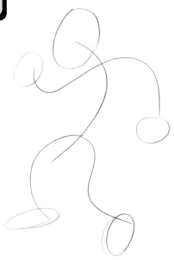

1 Line of Action

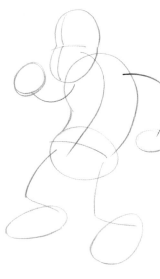

2 Sketch the Body

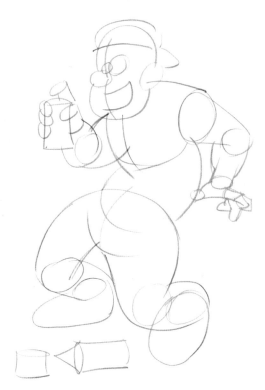

3 Add Volume

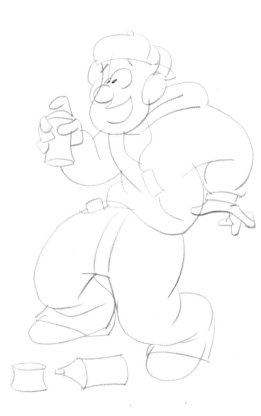

4 Sketch the Clothes

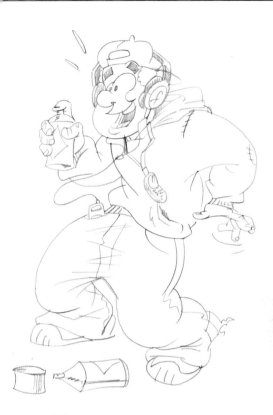

5 Finalize the Drawing

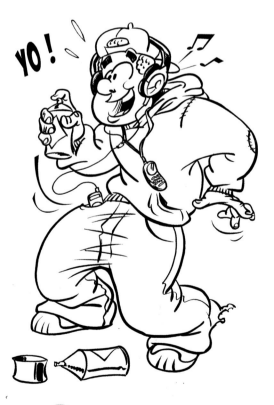

6 Outline

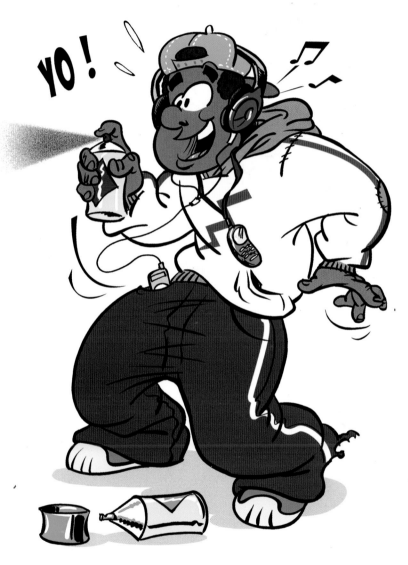

7 Add Color

Goofy Guy

1 Line of Action

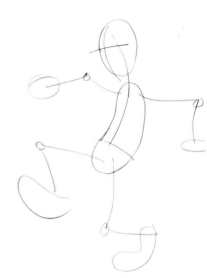

2 Sketch the Body

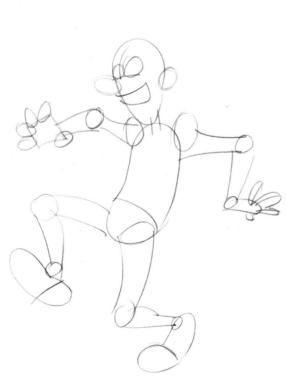

3 Add Volume

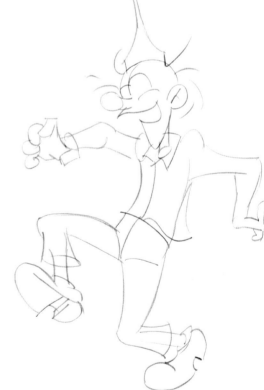

4 Sketch the Clothes

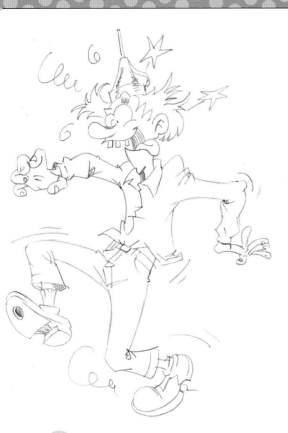

5 Finalize the Drawing

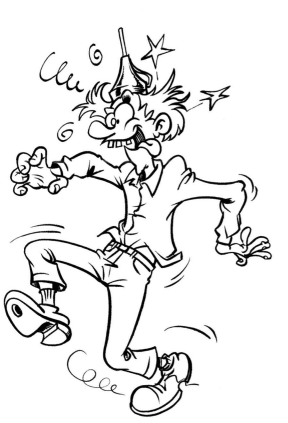

6 Outline

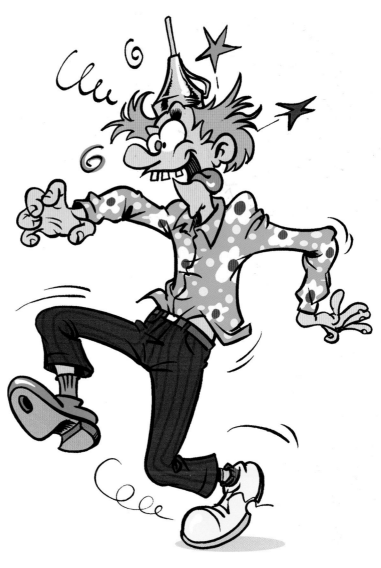

7 Add Color

The Eccentric

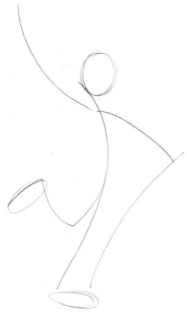

1 Line of Action

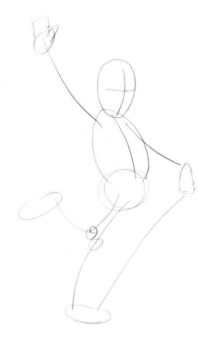

2 Sketch the Body

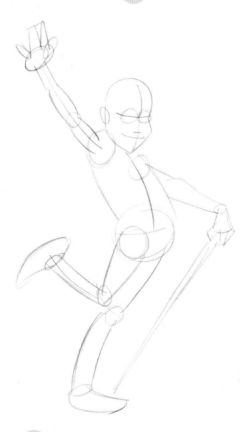

3 Add Volume

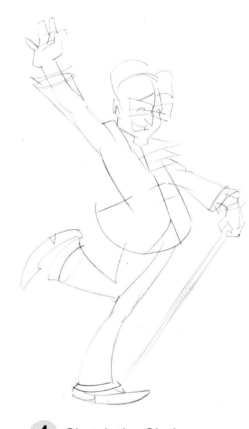

4 Sketch the Clothes

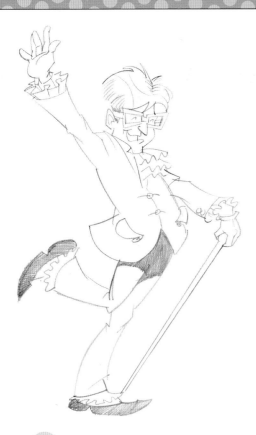

5 Finalize the Drawing

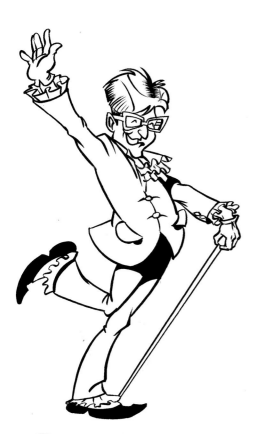

6 Outline

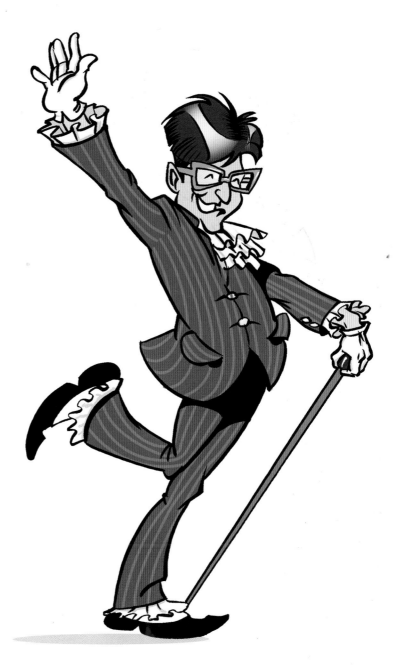

7 Add Color

The Corny Singer

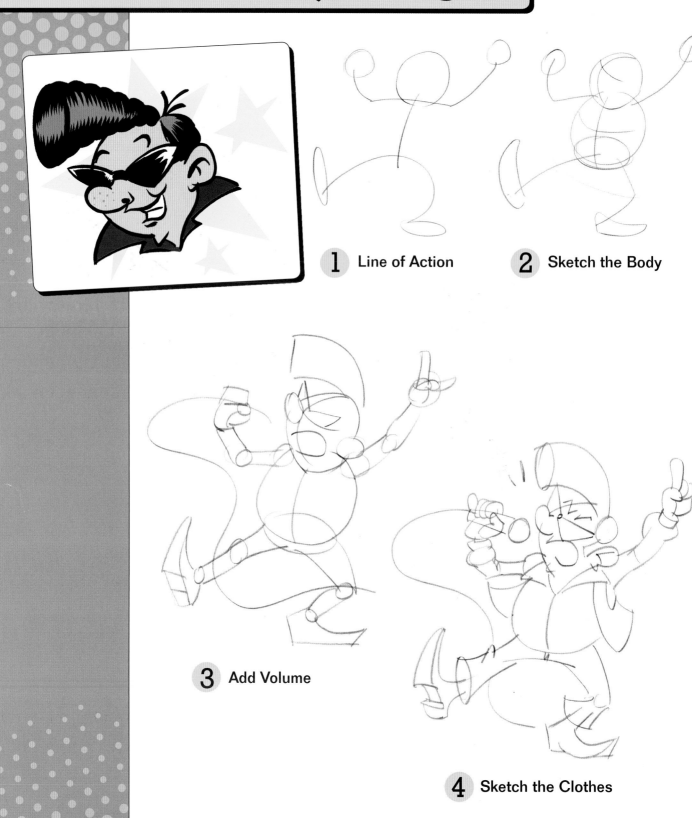

1 Line of Action

2 Sketch the Body

3 Add Volume

4 Sketch the Clothes

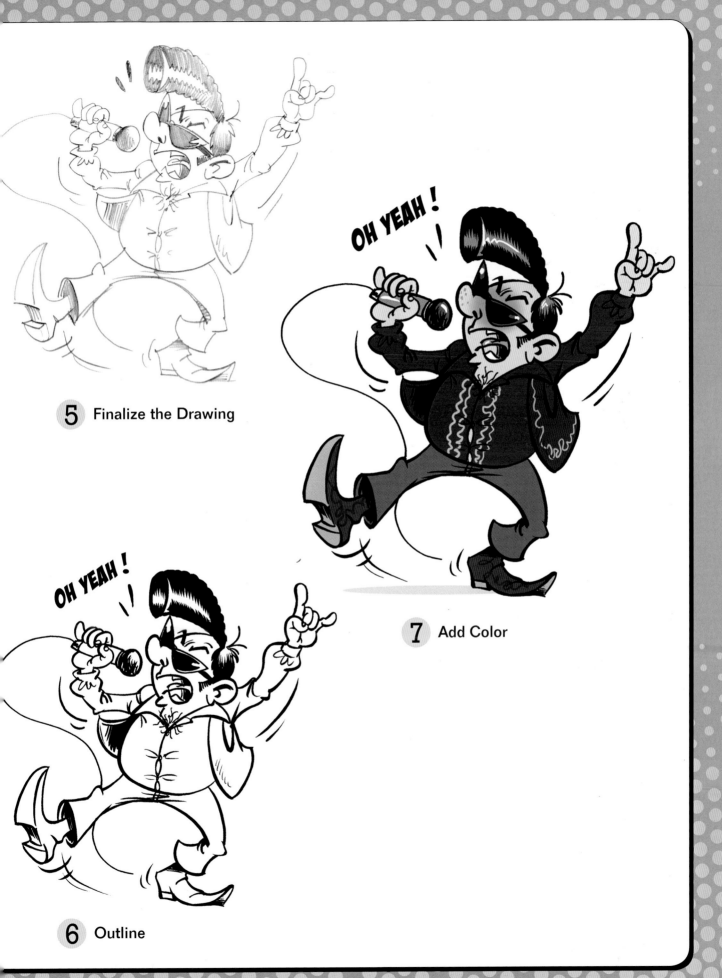

5 Finalize the Drawing

6 Outline

7 Add Color

OH YEAH !

The Sunday Athlete

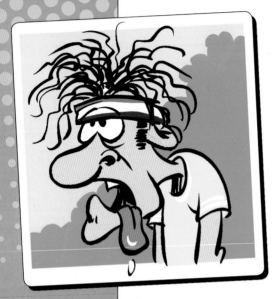

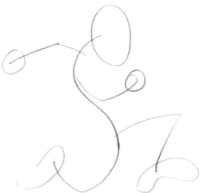

1 Line of Action

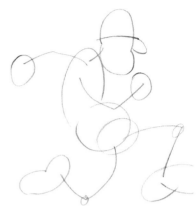

2 Sketch the Body

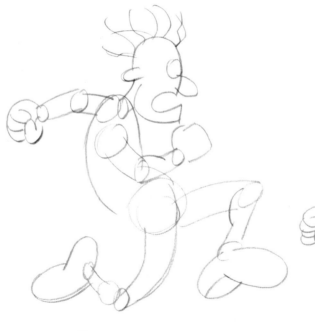

3 Add Volume

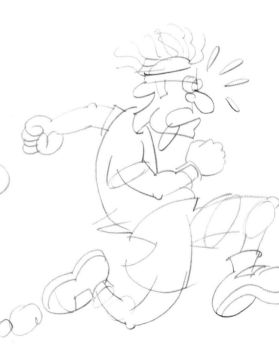

4 Sketch the Clothes

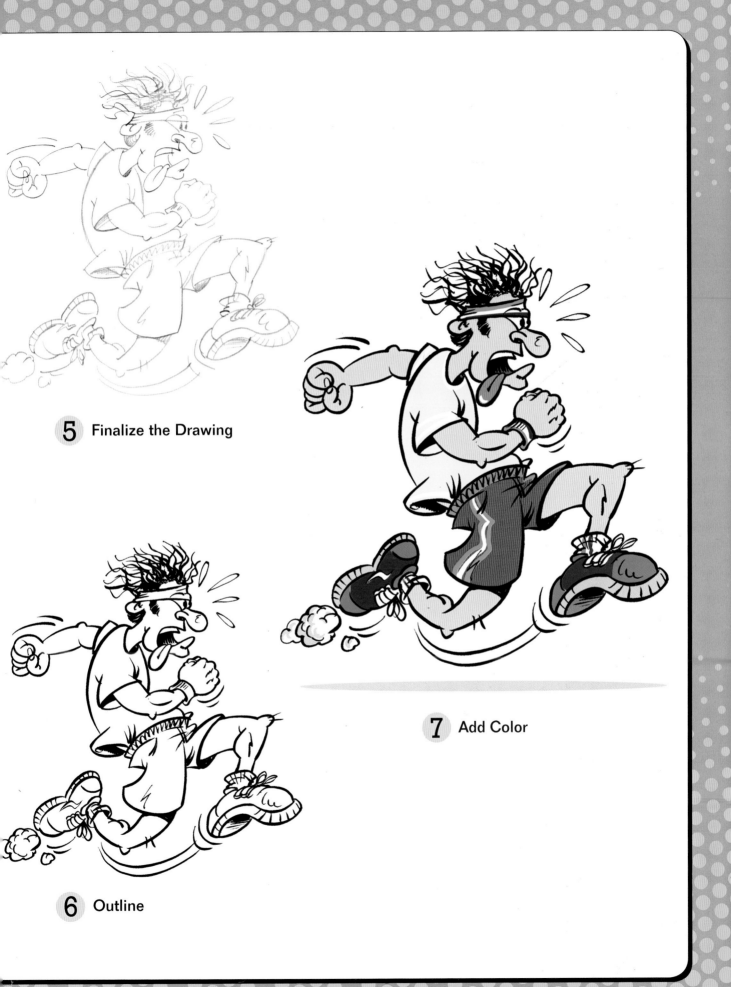

5 Finalize the Drawing

6 Outline

7 Add Color

The Bully

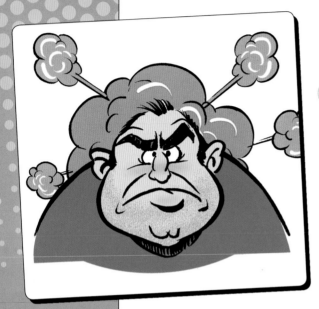

1 Line of Action

2 Sketch the Body

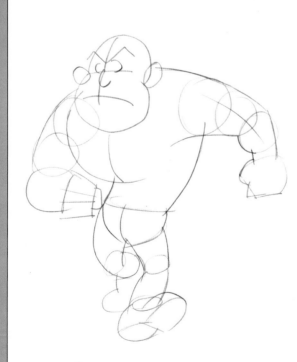

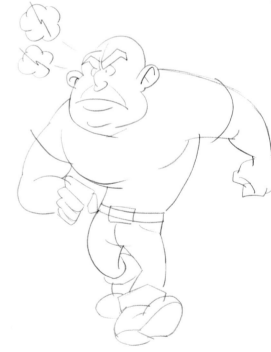

3 Add Volume

4 Sketch the Clothes

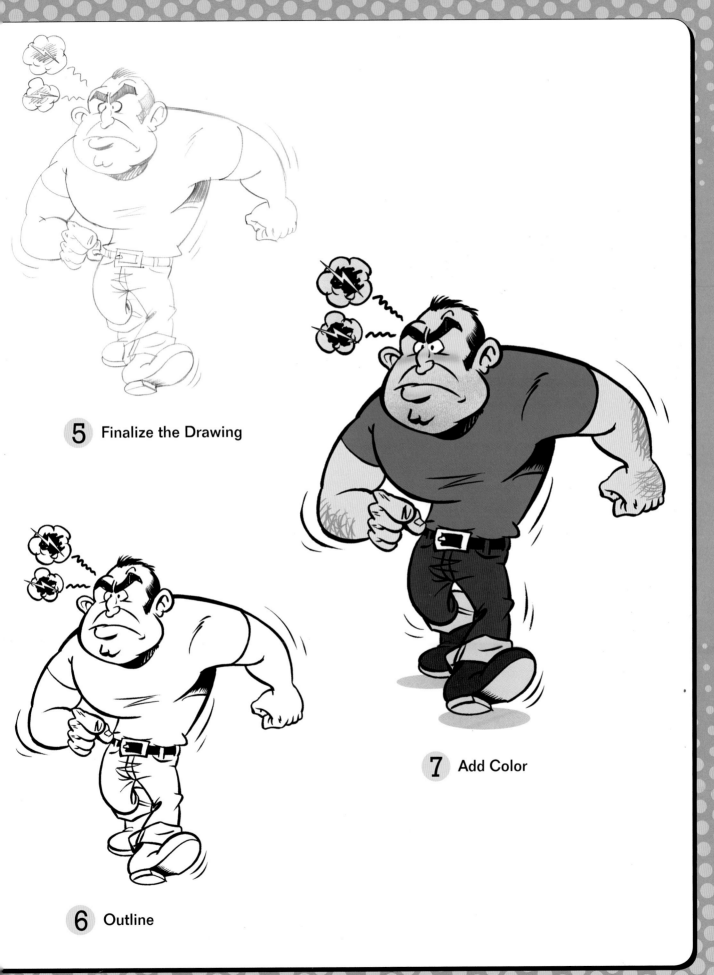

5 Finalize the Drawing

6 Outline

7 Add Color

Scooter Rider

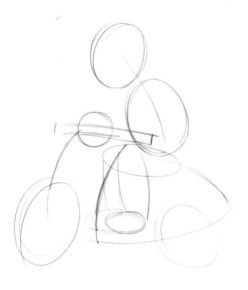

1 Line of Action

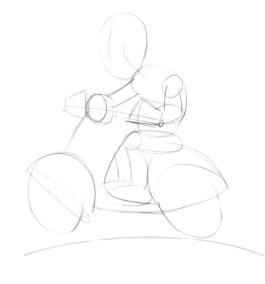

2 Sketch the Body

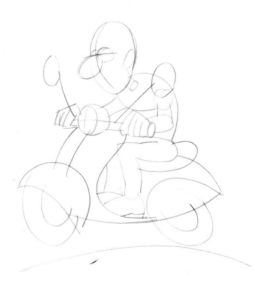

3 Add Volume

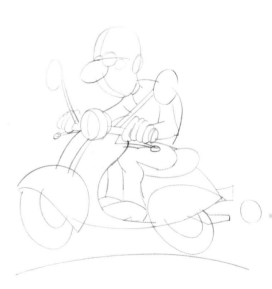

4 Add Detail

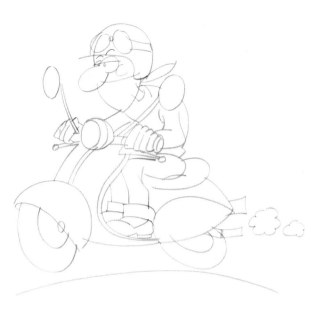

5 Sketch the Clothes

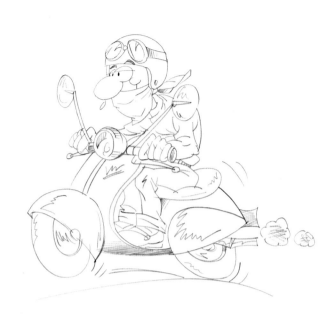

6 Finalize the Drawing

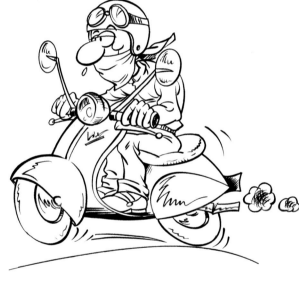

7 Outline

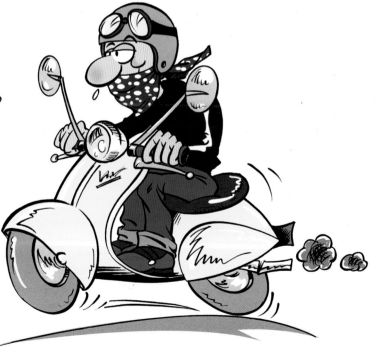

8 Add Color

The Crazy Driver

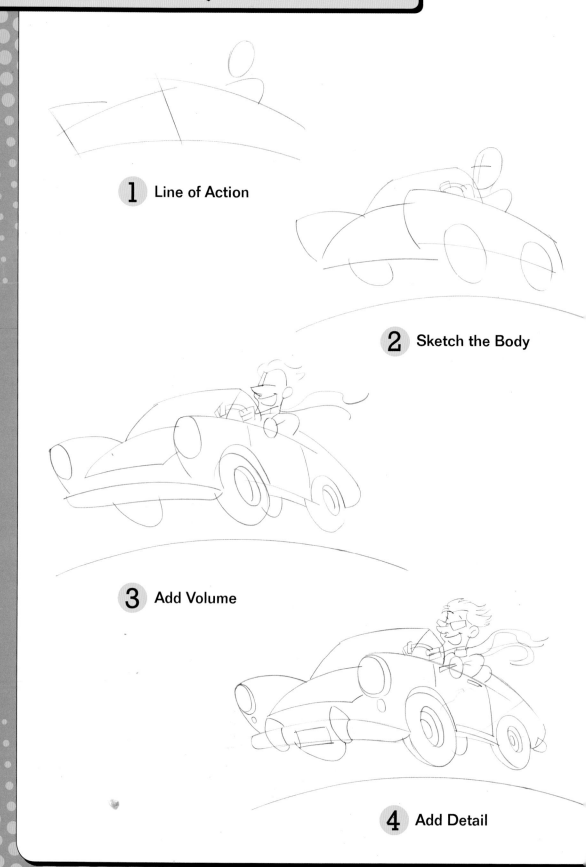

1 Line of Action

2 Sketch the Body

3 Add Volume

4 Add Detail

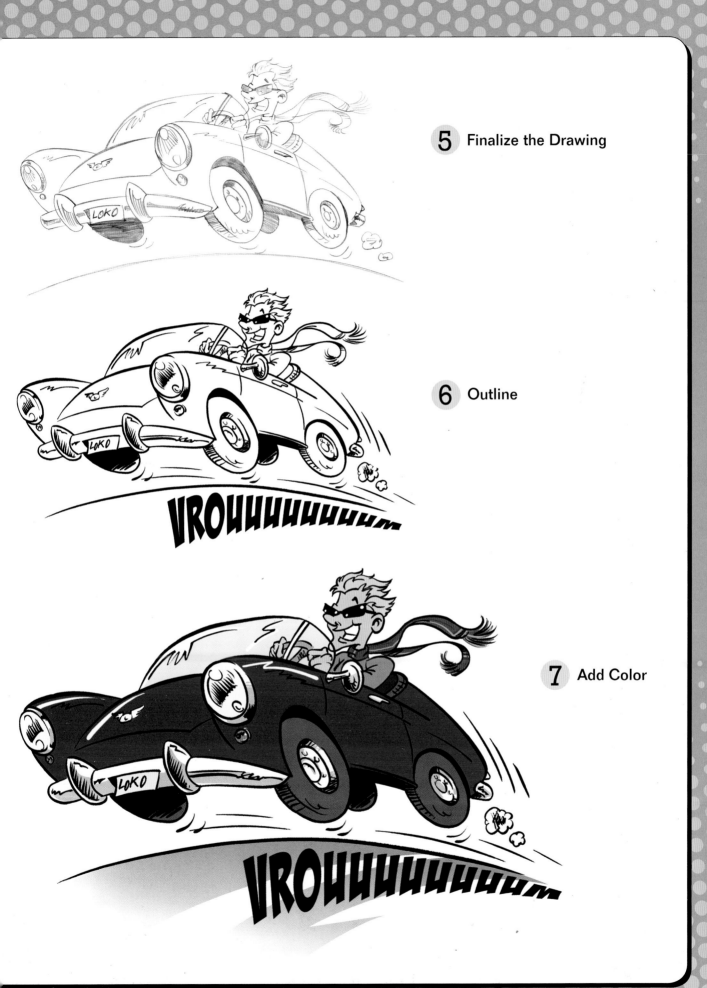

5 Finalize the Drawing

6 Outline

VROUUUUUUUUUM

7 Add Color

VROUUUUUUUUUM

Fun to Draw Funny Characters. Copyright © 2011 by
T. Beaudenon. Manufactured in China. All rights reserved.
No part of this book may be reproduced in any form or by
any electronic or mechanical means including information
storage and retrieval systems without permission in writing
from the publisher, except by a reviewer who may quote
brief passages in a review. Published by IMPACT Books,
an imprint of F+W Media, Inc., 4700 East Galbraith Road,
Cincinnati, Ohio, 45236. (800) 289-0963.
First Edition.

 Other fine IMPACT Books are available from your
favorite bookstore, art supply store or online
supplier. Visit our website at fwmedia.com.

15 14 13 12 11 5 4 3 2 1

DISTRIBUTED IN CANADA BY FRASER DIRECT
100 Armstrong Avenue
Georgetown, ON, Canada L7G 5S4
Tel: (905) 877-4411

DISTRIBUTED IN THE U.K. AND EUROPE
BY F&W MEDIA INTERNATIONAL LTD
Brunel House, Forde Close, Newton Abbot, TQ12 4PU, UK
Tel: (+44) 1626 323200, Fax: (+44) 1626 323319
Email: enquiries@fwmedia.com

DISTRIBUTED IN AUSTRALIA BY CAPRICORN LINK
P.O. Box 704, S. Windsor NSW, 2756 Australia
Tel: (02) 4577-3555

ISBN 978-1-4403-1490-2

Cover Designed by Laura Spencer
Production coordinated by Mark Griffin
Originally published in French by Éditions Vigot, Paris,
France under the title: Je dessine deshéros rigolos ©
Vigot, 2007